Doodling in
FRENCH

chefs d'accusation consistaient dans les charges absurdes articulées contre eux par Robespierre, dans ses discours à la Convention ¹. Chaumette raconta, devant le tribunal, les longues séances de la municipalité contre le côté droit, sans produire le décret qui put inculper les accusés : le misérable Hébert, il détailla de son arrestation par ordre de la commission ; il déclara que Roland avait cherché à corrompre des publics en lui offrant, à lui Hébert, d'acheter son journal. Détournelle vint déposer que les accusés avaient leurs efforts pour détruire la municipalité, qu'ils s'étaient aux massacres dans les prisons, et qu'ils avaient voulu d'une garde départementale. De tous les témoins qui dé-nt contre eux, Chabot fut le plus violent : il leur attribua politique machiavélique depuis le commencement de la Ré-n ; ils cherchaient, dit-il, à tirer avantage pour leur parti les évènements ; ils avaient même toléré les massacres de dans l'espoir que parmi les victimes se trouveraient ns de leurs ennemis. Le procès ne dura cependant

à la Convention : « Déjà cinq jours ont été consacrés à ce témoins seulement ont été entendus ; chacun, en faisant sa croit obligé à donner toute l'histoire de la Révolution. La accusés rend interminables leurs discussions avec les témoins. sera donc jamais fini. Mais pourquoi, nous demandons-nous, des témoins? La Convention, la République tout entière sont eurs, les preuves du crime des accusés sont évidentes. Chacun est dans sa conscience de leur culpabilité. Cependant, le tribunal rien faire de sa propre autorité ; il est tenu de suivre la loi. C'est à ntion d'écarter les formalités qui embarrassent notre marche » tion, sur la motion de Robespierre, adopta la résolution sui-us les termes mêmes d'une pétition que lui avait adressée à ce h des Jacobins : « Après trois jours de débats, le président du utionnaire demandera aux jurés si leur conscience est suffi-irée ; s'ils répondent négativement, le procès sera continué u trois jours, le président ouvrira la séance suivante en de-aux jurés si leur conscience est suffisamment éclairée. Si les jurés nt oui, il sera procédé sur-le-champ au jugement. Le président ne ra aucune espèce d'interpellation ni d'incident contraires aux dispo-e la présente. » (Papiers inédits trouvés chez Robespierre, II, 4.) ch. IX, § 40.

'qu'ils déclarent qu'ils sont en état de prononcer. » (Moniteur, 93.) — L'original de ce décret, écrit de la main de Robespierre, es qu'on va lire, fut retrouvé dans ses papiers après sa mort : que le jugement d'une affaire portée au tribunal révolutionnaire

Doodling in
FRENCH

How to Draw with
Joie de Vivre

Anna Corba

CHRONICLE BOOKS
SAN FRANCISCO

Library of Congress Cataloging-
in-Publication Data available

ISBN: 978-0-8118-7802-9

Manufactured in China

Designed by Emily Dubin

10 9 8 7 6 5 4 3 2

Chronicle Books LLC
680 Second Street
San Francisco, California 94107
www.chroniclebooks.com

ANATOLE FRANCE · PAGES CHOISIES

TABLE DES MATIÈRES

Thank you

Jo Packham

Bridget Watson Payne

Ryan Khavari

Nicolas

and

Bill

ANATOLE FRANCE

PAGES CHOISIES

CLASSIQUES ILLUSTRÉS VAUBOURDOLLE

LIBRAIRIE HACHETTE

16

TABLE OF CONTENTS

INTRODUCTION

I sometimes wonder what the first doodle was. A charcoal line smudged on a cave wall, a circle drawn with a stick in the sand, or merely the trace of a mother's finger along her child's outstretched hand. When did making one's mark in the world become a more defined pastime? Perhaps it began with sketching and drawing and detoured back into doodling when our minds became more engaged in intellectual pursuits and our newly idle hands went searching for a way to express their forgotten usefulness. No matter our progression into busy-ness and obligation, the elemental act of putting pencil to paper will forever beckon us. Lost in the rhythm of our markings, our minds are granted a momentary pause from their linear march. And while these scratches, dots,

14

and curlicues may begin as nonsense, it is these very components that give rise to unexpected beauty as we doodle our way into decorative originality.

So how does any of this get us to France? Well, I believe doodling in French is all about a dream—a dream of French style and *savoir-faire* that can come to play in your own backyard wherever that may be. The French exhibit a sense of decorative flourish that I find whimsical, beautiful, and lyrical all rolled into one. Why draw a line when a curve is more graceful? Why a straight edge when a scallop appears that much more charming? And when they do draw a line? Well, just look at those mansard roofs, revealing an elegance that only that type of precipitous slant affords. Their courtyards embrace symmetry, while their boulevards stretch wide in logical progression. And as with the espaliers that are trimmed and coaxed into geometrical arrangements from which curling tendrils come spilling out, this orderliness creates a steady backdrop on which flourishes can thrive. And after the flourish? Well a little embellishment of course! The French are known for that extra touch—a button, a bow, a ruffle, a garnish, a final note that signals all is well, all has been attended to, life can now proceed in harmony as no detail has been overlooked.

This is not to discount a certain hardy simplicity that can be found more often in the countryside. It is in smaller towns and villages that have held their ground throughout their long history that we find a more practical and rustic style, patterns and colors borrowed from nature, food and lines drawn from

the earth. Pottery and textiles and the shapes of the houses themselves suggest a solid underpinning, a connection to quotidian endeavor that is as much a signature of French design and attitude as any of its fancier cousins. Formal gardens give way to *jardins potagers*, fully turreted *châteaux* melt into beekeeper huts, and it is the merging of these two worlds that I find fascinating and hope to capture in this book.

Each of the six chapters within revolves around a slice of French life . . . cultivating the garden, embellishing one's home, gathering with friends at the local café, packing up a small valise and heading off to the city or nearby beach, marveling at iconic French elements, and finally coming to rest back in one's favorite spot to reflect or

dream up new adventures and desires. In the course of these events, doodling comes to play, perhaps as a diary, perhaps as a way to illustrate a story, perhaps merely a random thought or impulse of the imagination. There are no formal rules–that is the beauty of a doodle (or as the French would call it, *le griffonnage*). Wherever you are, whenever you like, a pencil and piece of paper is all that is needed. Use your powers of observation or use your imagination; both are equally valuable.

I generally carry a small notebook with me to catch my musings, but just as often I'll turn to an interesting scrap of paper I've found on the sidewalk or the inside of a matchbook cover if I get desperate! Making use of unexpected surfaces lends an element of

uniqueness and surprise to a doodle; different textures and shapes have a way of influencing where any given drawing might go. And because I like my drawings to find a home eventually, I often capture them within collages created just for them. This way, the simple act of doodling can evolve into a journey of further creative exploration.

I invite you to use this book as a guide and inspiration toward doodling possibilities. Often doodles are viewed as the subconscious bringing forth of images or of design that is not actually being looked at. I am a fan of this dreamy and random approach, but I also believe doodling can be more thoughtful and defined. It's really up to the individual. The doodles in this book veer toward sketching only because that is what

I find my hand does most naturally. I may look at something, I may not; either way I rest my mind and allow my hand to wander and circle around an idea, adjusting and fine-tuning gradually so that the shapes and lines find me as much as I find them. Eventually an image will begin to form in a loose way; I may fiddle with an eraser and then begin to darken outlines to give definition. The final doodle may be something close to its initial gestures or have expanded into more than I would have guessed. The how-to illustrations found before each drawing help break down this meandering process into manageable parts, giving you a sense of how to arrive at a final image by taking small steps and adding layers. By practicing some basic shapes and curves (and curlicues for all things French!)

over and over, you will begin to get a feel for a drawing's progression and will soon be able to incorporate the steps into the underlying structure of your own doodles.

The collages are arrived at in a similar manner. I purposefully choose specific colors and imagery to support any particular doodle; I may think about trying to convey a story or simply put items together that work with each other in a playful manner. It is through a balance of experimentation, discovery, and a dash of critical thinking that a final scheme takes hold. This process allows any given collage to have a hand in its own making. Some come easily, others become arranged in a way I couldn't have foreseen, and a few simply need to be wrestled into submission! Ultimately, I like to keep

these compositions relatively simple, allowing each element to have its own visibility rather than getting lost in a sea of imagery.

As you embark upon your own doodling destiny, I invite you to experiment to your heart's content. At the back of this book is a specially designed section where you can practice your own drawings within ready-made collages. Try doodling randomly throughout any given day in your own notebook, or set aside time each week to open up to these pages and see what comes. There is a beauty in slowing down enough to observe your own creative process. Not every doodle needs to be important; in fact many of them are simply momentary diversions. Yet for those of us who choose to doodle in French, they can also be whimsical forays into a world

we might not enter any other way. If we are not actually sitting at a zinc-topped bistro table on a tree-lined boulevard in Paris, at least we can doodle ourselves alongside one. If you cannot find the beret that you always imagined you would have by now, then reach for your pencil and create a version that makes you feel chic just by looking at it. If a baguette is calling your name and the French bakery is miles away, doodle yourself three luscious loaves (and don't forget the crumbs).

Be simple. Be bold. Always be yourself and cultivate your dreams, and when your heart desires, by all means dream in French.

Bonne journée,

DANS LE JARDIN

ENVIRONS DE PARIS

LE BOIS DE BOULOGNE

Le Bois de Boulogne, une des merveilles de la capitale,
t l plus délicieuse promenade qu'on puisse rêver. Il est,
le rendez-v la haute société parisienne :
nages s'y pressent con-

de la Place de la
Élysées
trice)

es
e

1

IN THE GARDEN

Doodling in the garden requires little more
than creating a cozy spot in your favorite
chair with a cushy pillow and a glass of lem-
onade. You might use a small sketch pad, but
it's also fun to work on more unexpected things
like the back of a seed packet or the bottom
of the box that carried your plants. Pin your
impromptu sketches up in your potting shed or
tuck them into the pages of a gardener's cata-
logue as a welcome surprise on a rainy day.

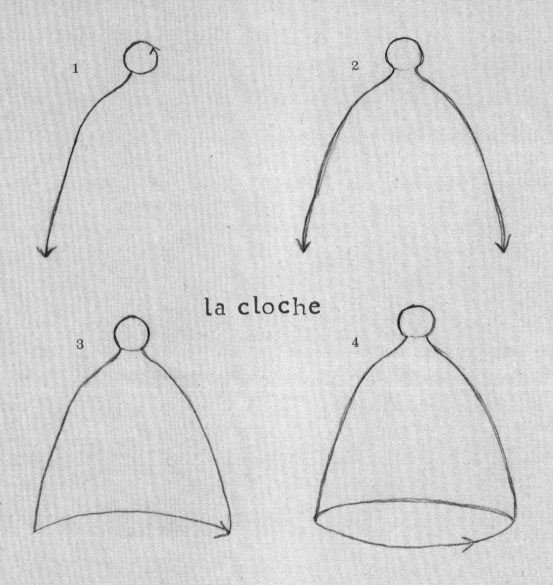

la cloche

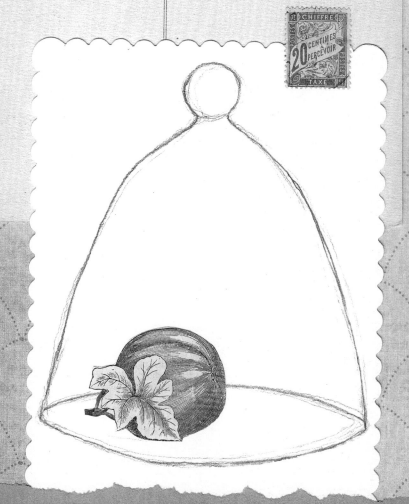

la topiaire

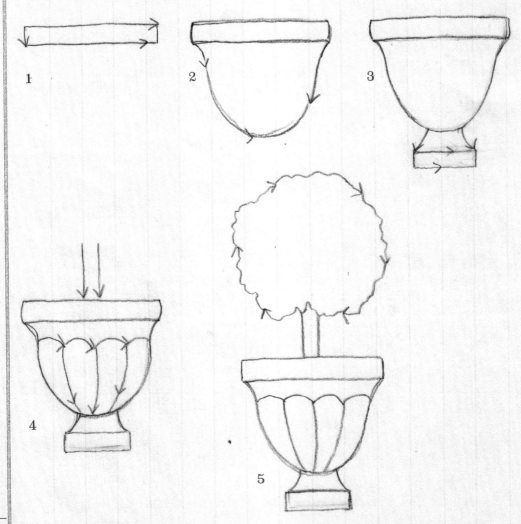

1

2

3

4

5

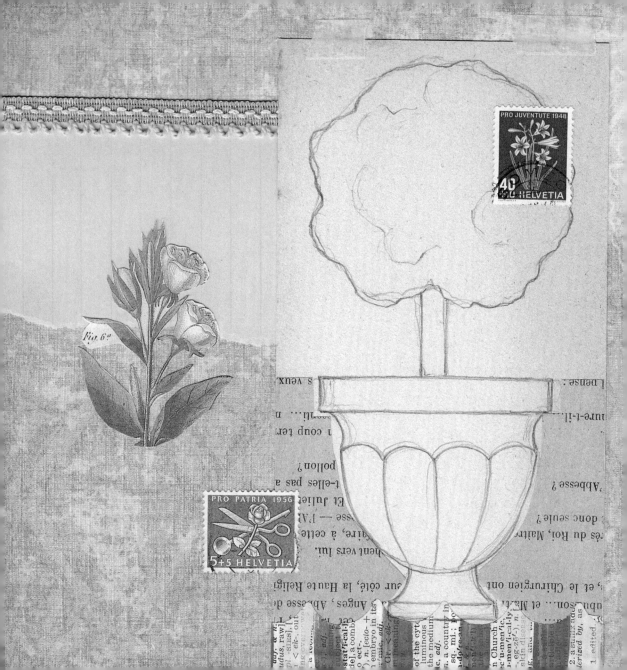

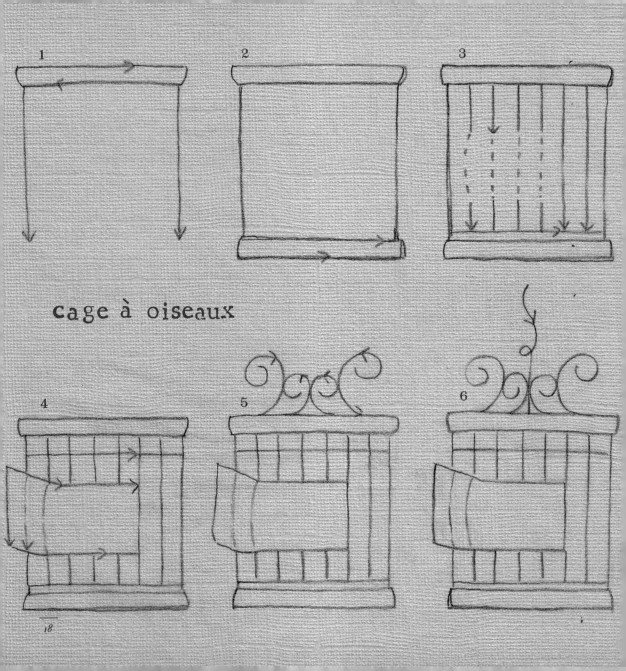

cage à oiseaux

1

2

3

4

5

6

18

l'arrosoir

1

2

3

4

5

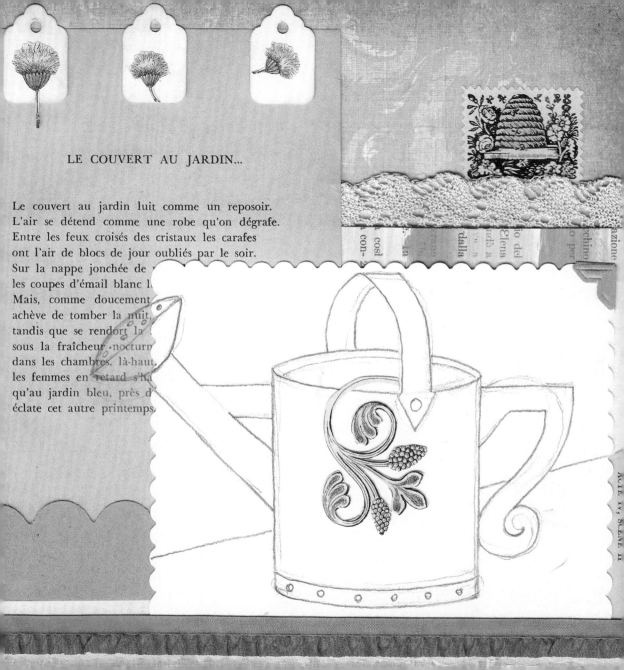

LE COUVERT AU JARDIN...

Le couvert au jardin luit comme un reposoir.
L'air se détend comme une robe qu'on dégrafe.
Entre les feux croisés des cristaux les carafes
ont l'air de blocs de jour oubliés par le soir.
Sur la nappe jonchée de
les coupes d'émail blanc l
Mais, comme doucement
achève de tomber la nuit,
tandis que se rendort la
sous la fraîcheur nocturn
dans les chambres. là-haut,
les femmes en retard s'h
qu'au jardin bleu, près d'
éclate cet autre printemps.

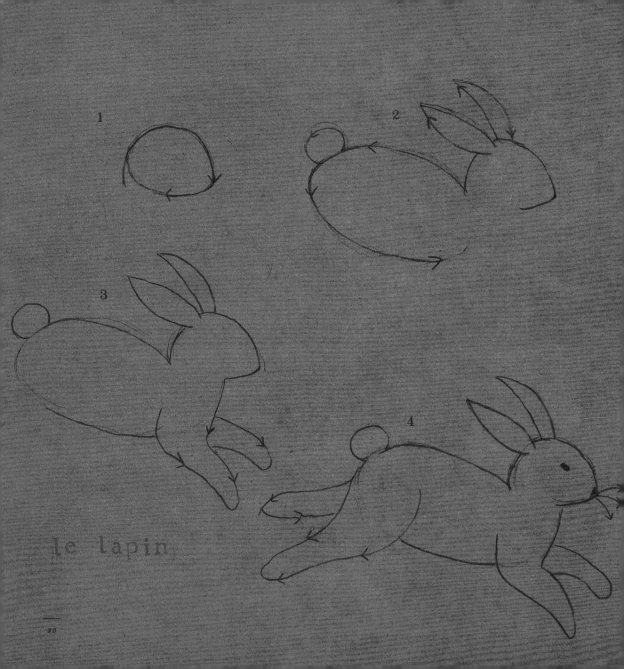

1

2

3

4

le lapin

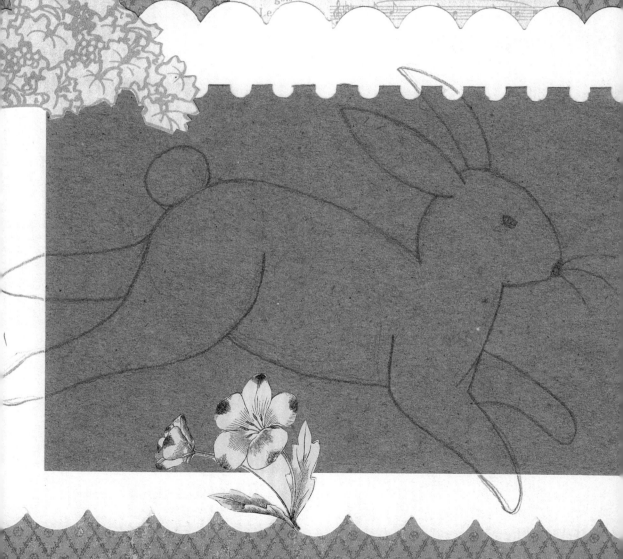

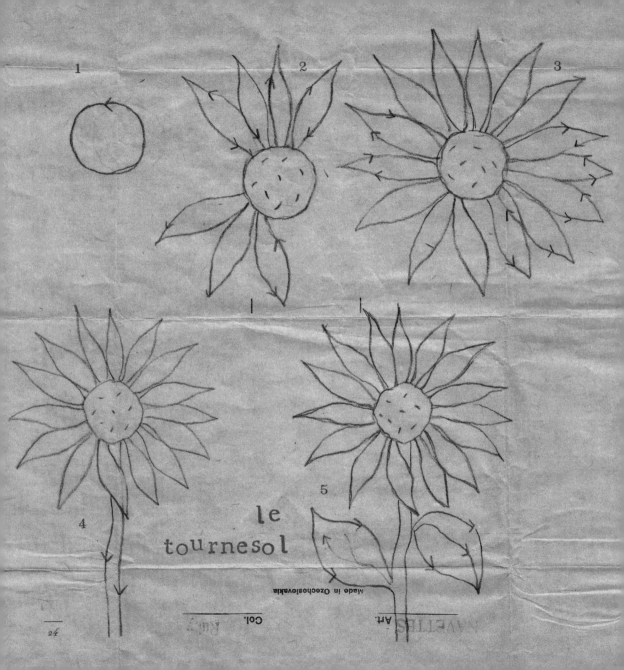

le
tournesol

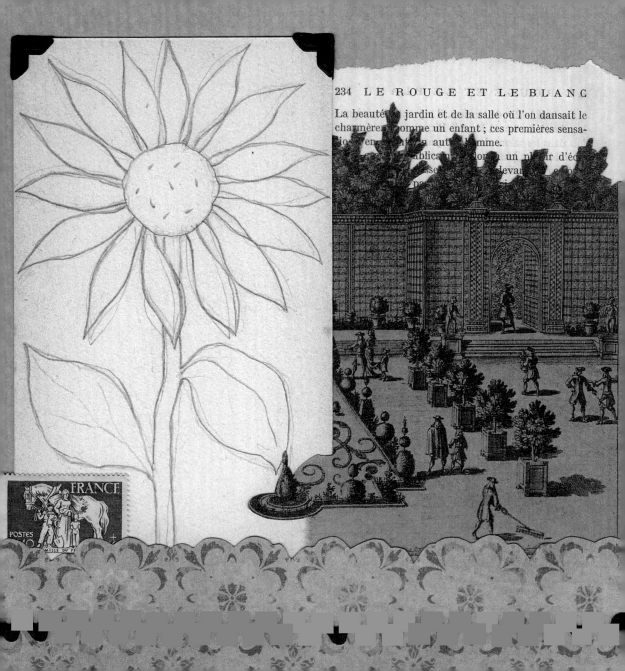

La beauté du jardin et de la salle où l'on dansait le charmèrent comme un enfant ; ces premières sensations l'emportèrent en autre homme.

... ublica... donna un plaisir d'éc...

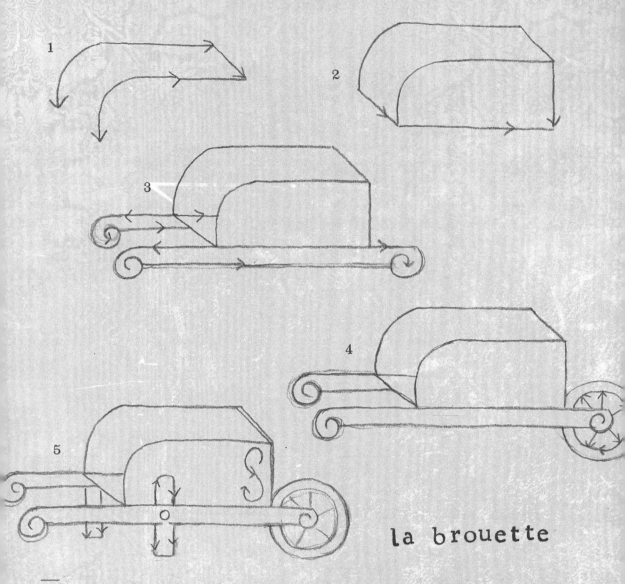

la brouette

MAISON
DE LA
BELLE JARDINIÈRE
HABILLEMENTS
TOUT FAITS ET SUR MESURE
pour Hommes et pour Enfants

la poire

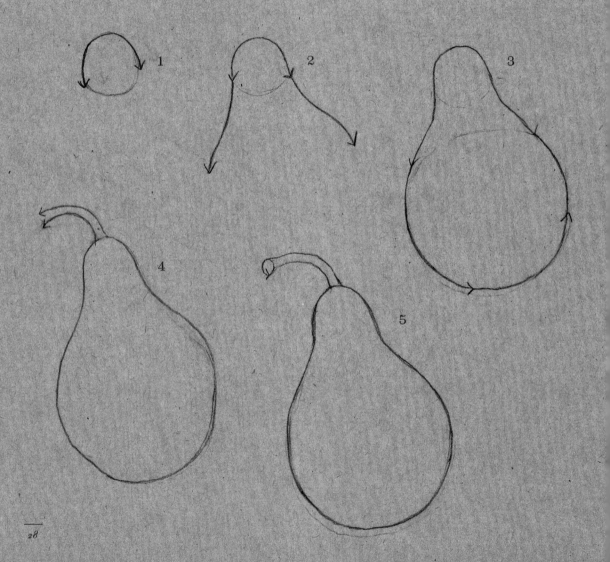

1

2

3

4

5

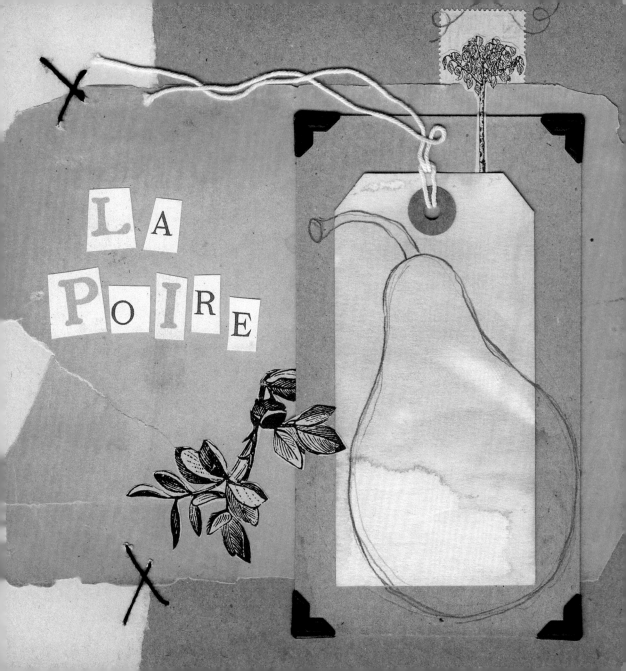

LA POIRE

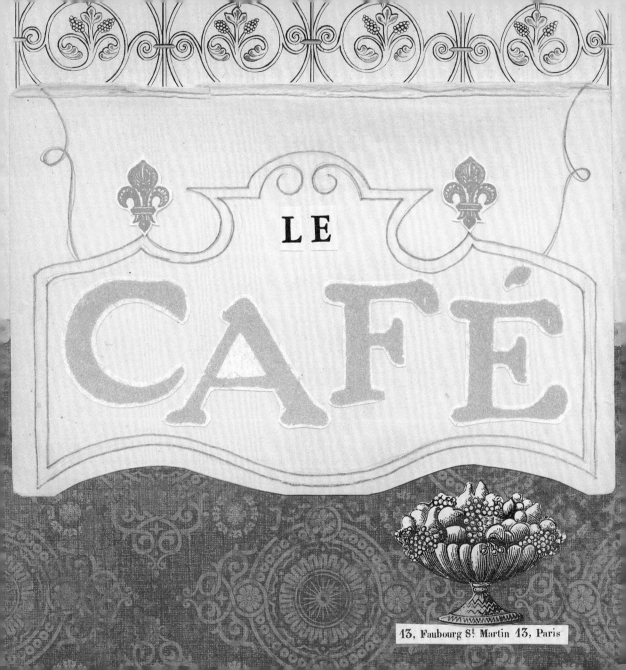

LE CAFÉ

13, Faubourg St. Martin 13, Paris

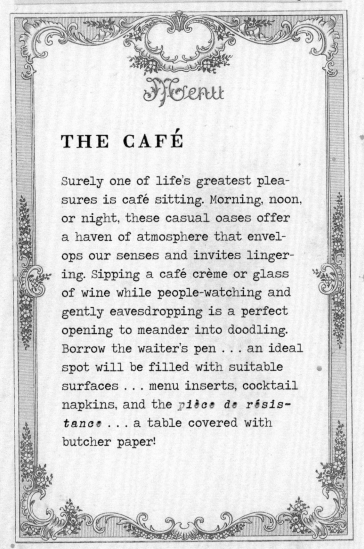

Menu

THE CAFÉ

Surely one of life's greatest pleasures is café sitting. Morning, noon, or night, these casual oases offer a haven of atmosphere that envelops our senses and invites lingering. Sipping a café crème or glass of wine while people-watching and gently eavesdropping is a perfect opening to meander into doodling. Borrow the waiter's pen . . . an ideal spot will be filled with suitable surfaces . . . menu inserts, cocktail napkins, and the *pièce de résistance* . . . a table covered with butcher paper!

1

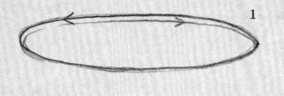

le café au lait

2

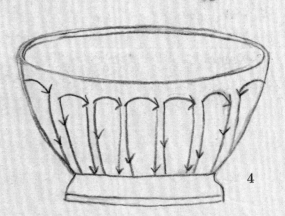

3

4

matin, *m.* morning; (poet.) morn,
forenoon; de bon —, early in
the morning; se lever —, to get
up early.

la chaise
de bistro

1

2

3

4

5

CARTE POSTALE

A

N° 19421

le croissant

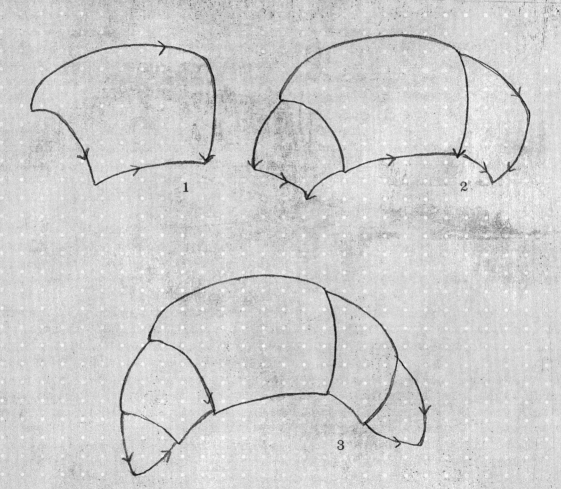

1

2

3

Extrait du Catalogue de **ÉMILE BENOIT** Editeur de Musique

13, Faubourg S.t Martin 13, Paris

ROMANCES, CHANSONNETTES, DUOS et CHŒURS pour PENSIONNATS

Approuvés par NN. SS. les Archevêques de Tours, Rennes, Avignon

NN. SS. ... St Brieuc, Versailles, Grenoble, Luçon, Troyes, Montpellier, Blois, Orléans, etc

	...AUTAGNE	G.	Boîte à soldats (la)..........	3 »	CHAUTAGNE	D.	Mémoires d'un
	...HACK	D.	Je ne le dirai pas.............	3 »	DURBEC	D.	Tache de prune
	...OURNY	D.	J'en voudrais	3 »	CHILLEMONT	D. G.	Tante Brigitte
	...ÉMENT	G.	Je suis un homme..............	3 »	PAUL HENRION	D.	Tartine mal ga
	...HILLEMONT	D.	Je suis vive...................	3 »	CARL VAN BERGHE	D.	Tic-tac de l'hor
	...me A. BATAILLE	D.	Jolie quêteuse (la)..........	3 »	D'HACK	G.	Toujours dernie
A...	...ARISOT	D. G.	...	3 »	DURBEC	D.	Trois âges d'en
Ang...	...CHAUTAGNE				LAGARDE	D.	Trois
Arlequi...	...POURNY				...URNY		
Au pays de...	...CHAUDO...						
Aumône (l').........	3 »	...MAC...					
Au village. (Valse ch...ée)......	4,50	...C...					
Ave Maris stella de M...rgareth	3 »						
Bal des fleurs (le)	3 »						
Baptême de Bébé (le)........	3 »						
Bâton de Maréchal (...							
...Bé...							

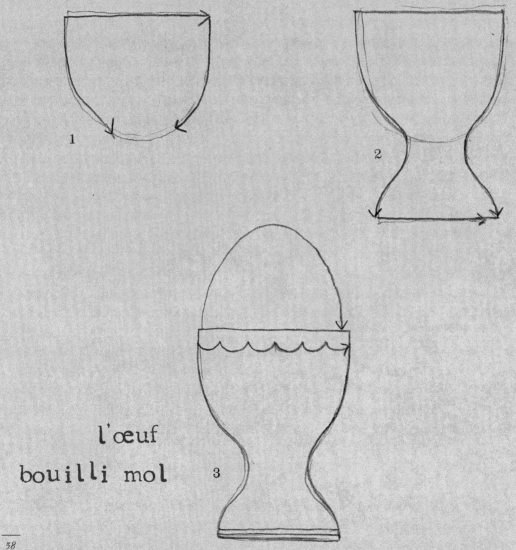

1

2

l'œuf
bouilli mol

3

Q
R

s et que cet enfa
shonneur de la
Monsieur Del
usieurs fois
il qu'on
érable
faire)
er d'escp
ette somme
mon si gra

2 3 4 5 6

la toque

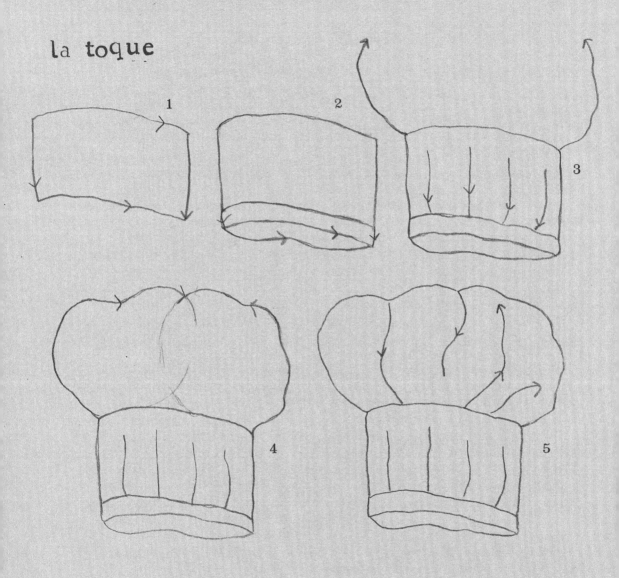

M _____

To _____

Terms. _____

REPUBLIQUE FRANÇAISE
POSTES
15

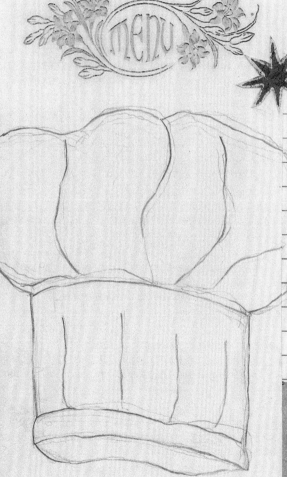

menu

CHICORÉE A LA MÉNAGÈR

La Meilleure **CHICORÉE**

est contenue dans le papier

GRAINS DE CAFÉ

CHOCOLAT INIMITABL

Pur Cacao et Sucre

UROYON & RAMETTE - CAMBRAI (No

imp. Th. DUPUY & FILS, 22, rue des Petits-Hôtels, Paris

ative adjectives shoul
r demonstrative adjectiv
morceaux de bois

ch is it? **Quels livres**

FEMININE
quelle plume
quelles plum

adjective. An adjec
rstion, is called an

my pins
his colors
your ink
their pencils

1. These are mine,
his, are on his desk
are your pictures.
8. Where are theirs?
are hers? 11. Wher
re these books yours?

hich hat is it?
d and which banners

le verre de vin

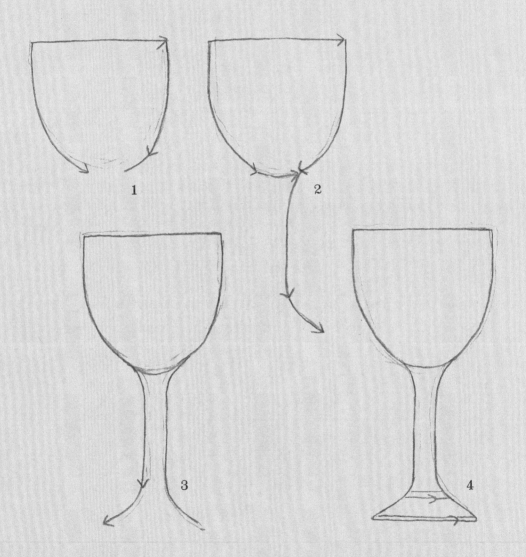

1

2

3

4

VIN DE PAYS

No. 5

Carte Postale
POST CARD — POSTKARTE — CARTOLINA POSTALE
TARJETA POSTAL

Adresse

Correspondance

8 sexe... 1 personne.
6 Gens, 1 personne.

...s qui sont :
1 pauvre homme,
1 homme, 1 Monsieur,
6 petit garçon,
4 camarade garçon,
5 garçon,
2 so-mbre,
enfants qui sont : —
Responsables

20 Groupe

SEX...

lins 49,2, qui...
des bénéficiaires...
il faut noter cette di...
mêmes et de leur produ...
conséquent, sur 4 filles et garçons...

LES NOTIONS MORA...

sont déjà...
sables mascu...
lins 49,2. S'il s...
... les t...
... m... i T v at i...

les pommes

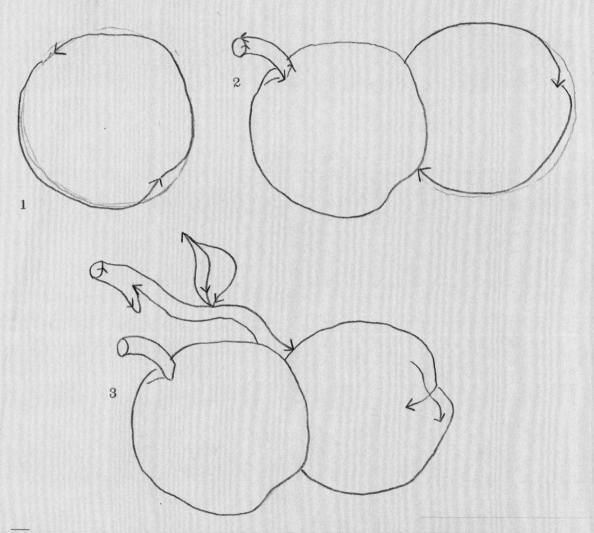

1

2

3

Vapeurs

Propriétés de la vapeur. La vapeur ainsi

se comporte comme un gaz quand on fait

CINNA

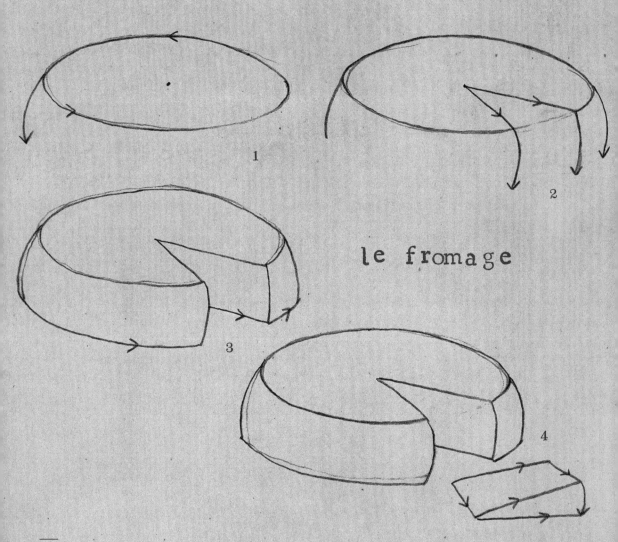

1

2

le fromage

3

4

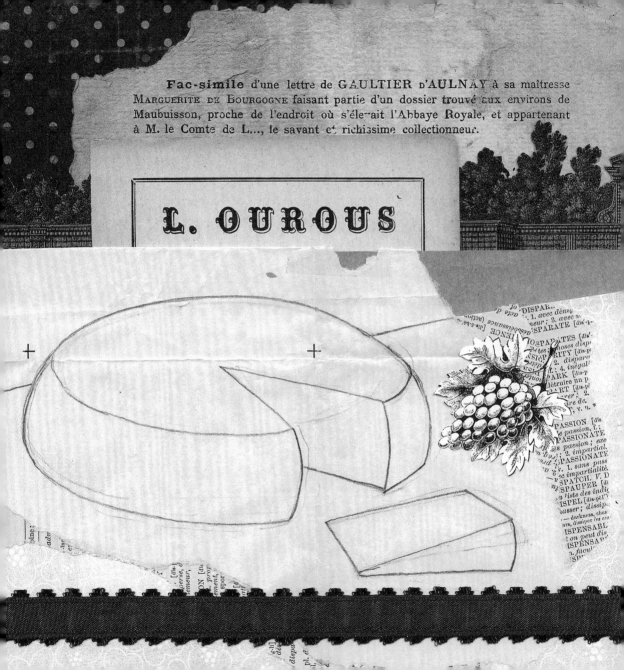

Fac-simile d'une lettre de GAULTIER D'AULNAY à sa maîtresse MARGUERITE DE BOURGOGNE faisant partie d'un dossier trouvé aux environs de Maubuisson, proche de l'endroit où s'élevait l'Abbaye Royale, et appartenant à M. le Comte de L..., le savant et richissime collectionneur.

L. OUROUS

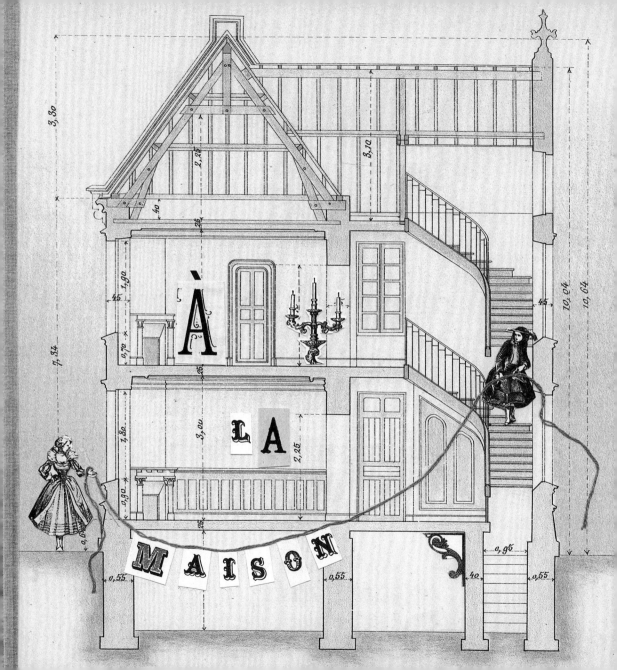

À LA MAISON

IN THE HOME

Doodling in your own home treads a path of quiet contemplation that can be both nurturing and surprising. Closely observing well-loved objects while taking the time to sketch through their shapes allows us to discover them afresh, leading to new appreciation for their beauty. Details of our everyday lives can begin to re-engage us with their forgotten charm. Re-using envelopes from discarded mail or sides torn from a market bag can help nudge your homegrown doodles in unexpected directions.

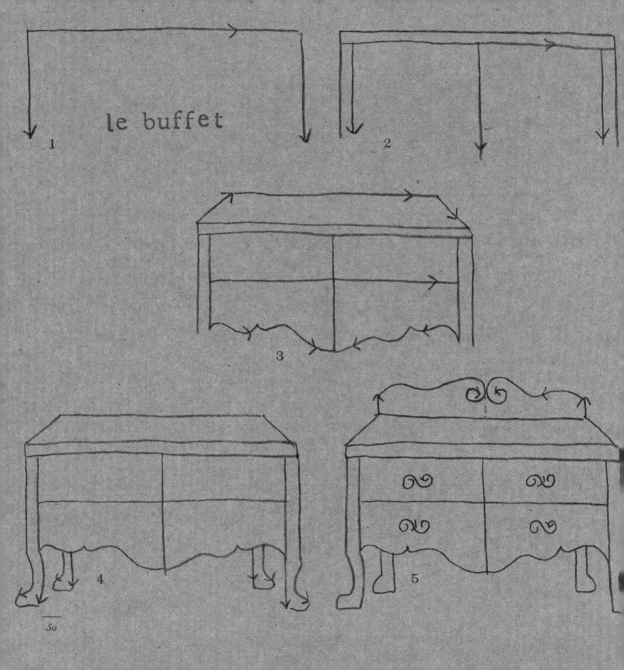

le buffet

1

2

3

4

5

50

ETUDE

pour le Piano - Forte

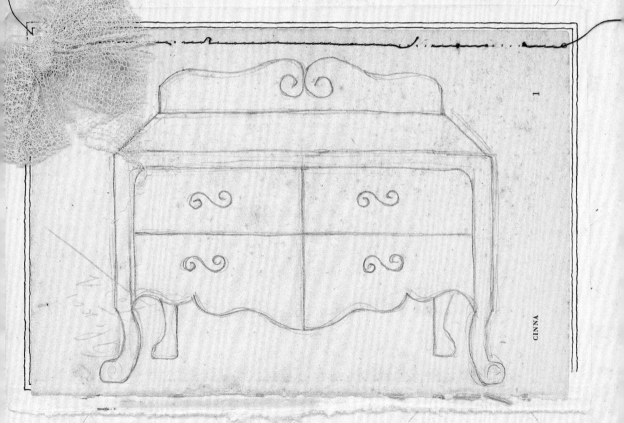

J. B. CRAMER.

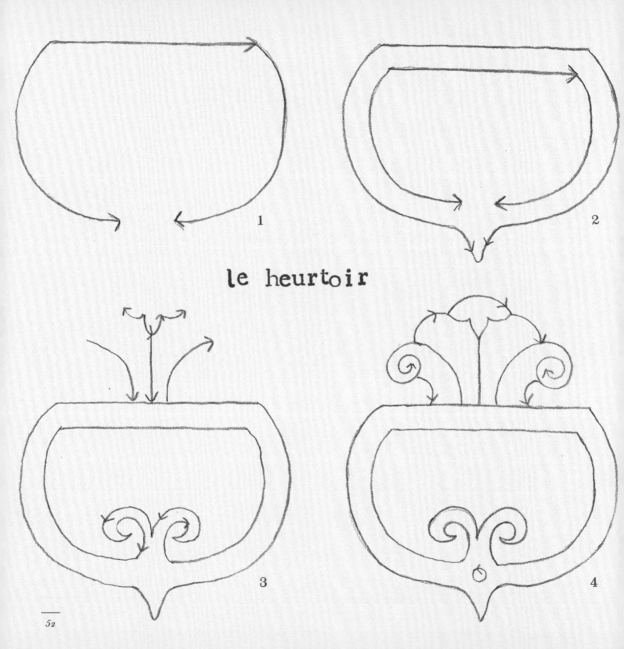

le heurtoir

1

2

3

4

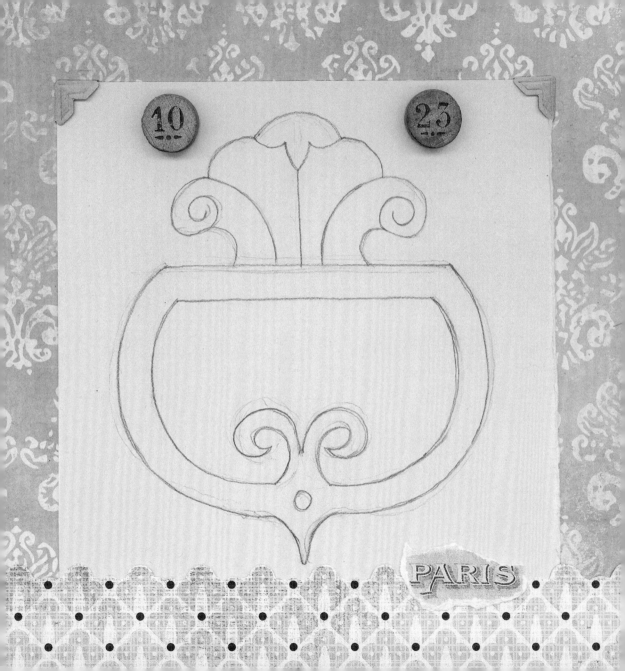

PARIS

le divan

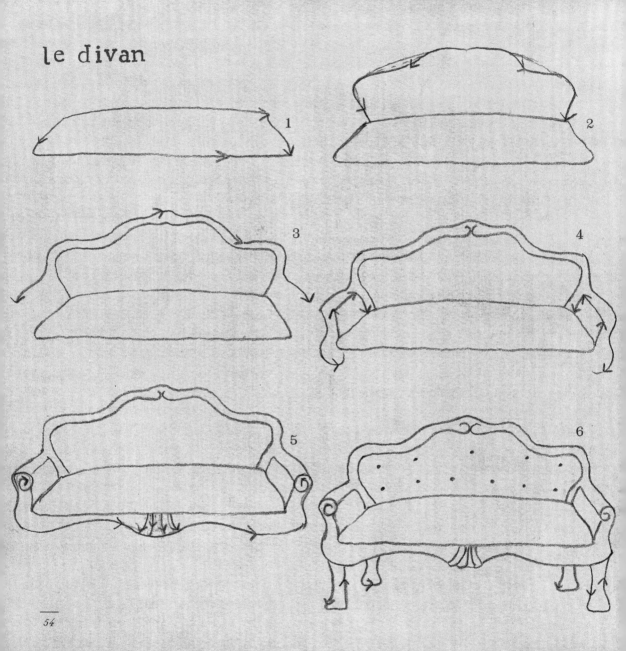

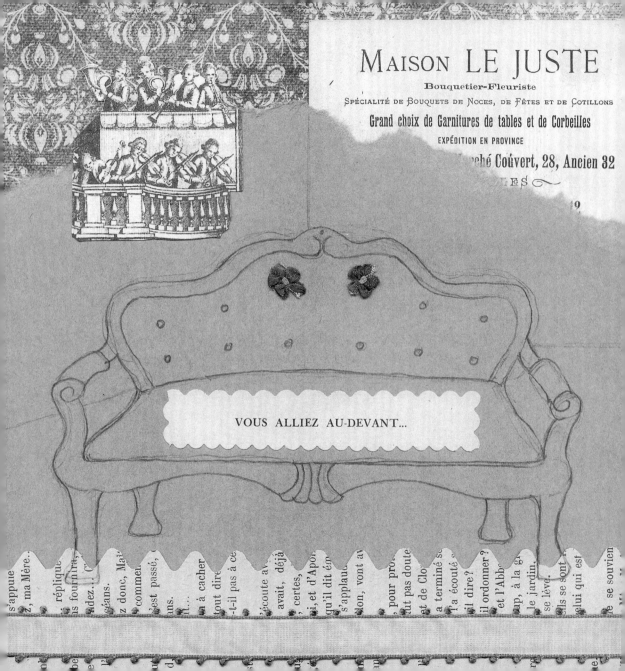

Maison LE JUSTE

Bouquetier-Fleuriste

Spécialité de Bouquets de Noces, de Fêtes et de Cotillons

Grand choix de Garnitures de tables et de Corbeilles

EXPÉDITION EN PROVINCE

...rché Couvert, 28, Ancien 32

...LES

VOUS ALLIEZ AU-DEVANT...

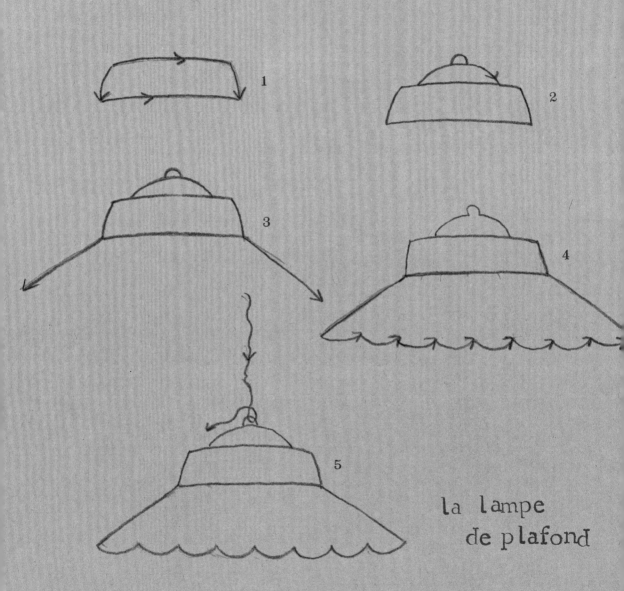

1

2

3

4

5

la lampe
de plafond

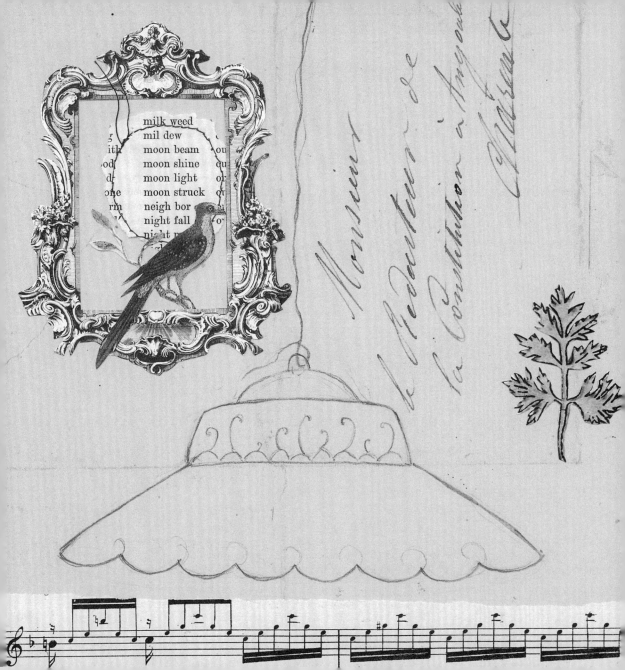

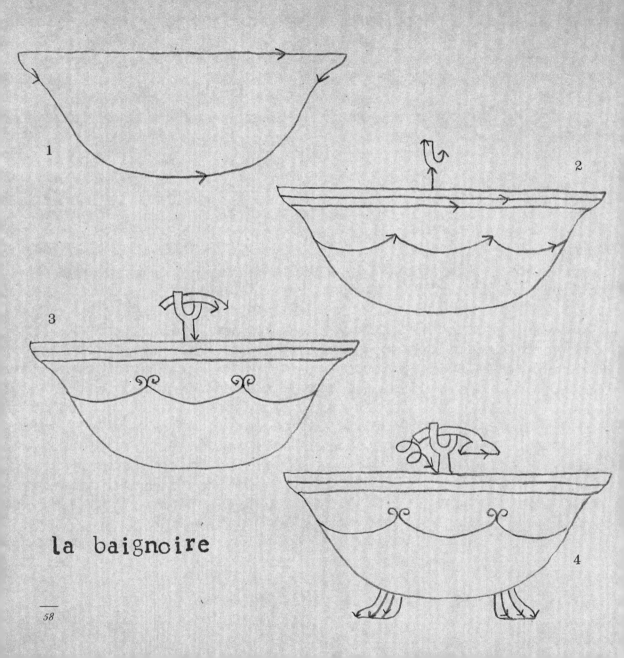

1

2

3

4

la baignoire

COLLECT

DE

MORCEAUX

POU

Piano à Qua

A. — MORCEAUX DE GENRE

Photographie
des Enfants de Montmartre

QUE

MENT

RTS

GORD.

la candélabre

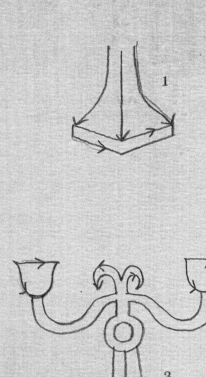
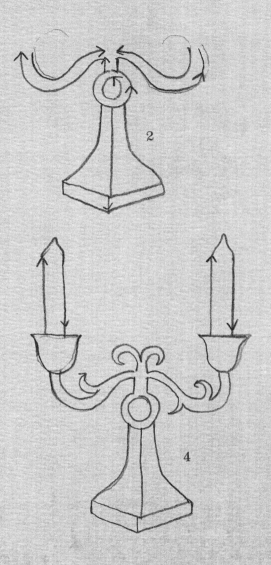

1

2

3

4

VOUS ET MOI

Nous vivons comme à l'ordinaire.
Nous travaillons et nous cousons...
Mais dans la maison de ma mère,
je ne suis plus dans ma maison.

princesses, et
sévères que celles des femmes d'autref

125

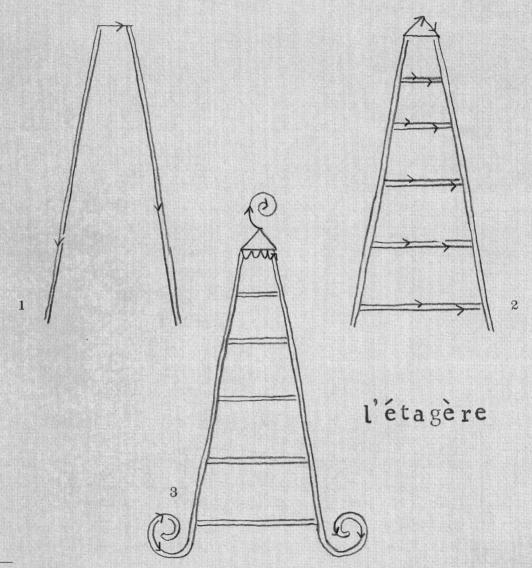

l'étagère

1

2

3

CHAPITRE V

PARIS EN SANG

Plan du Premier Etage.

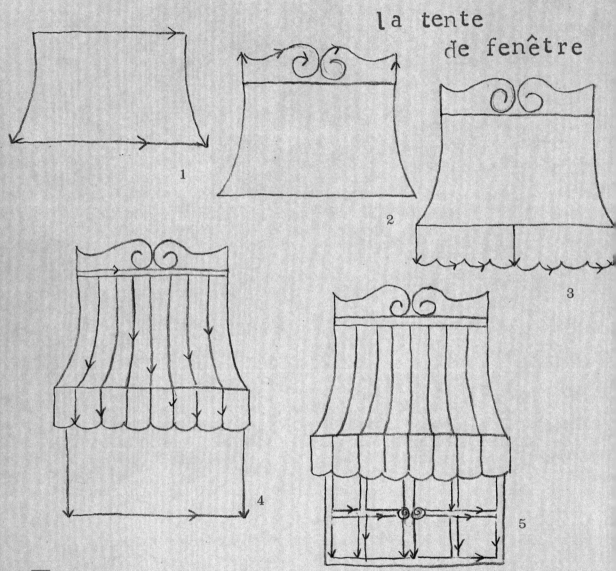

la tente de fenêtre

1

2

3

4

5

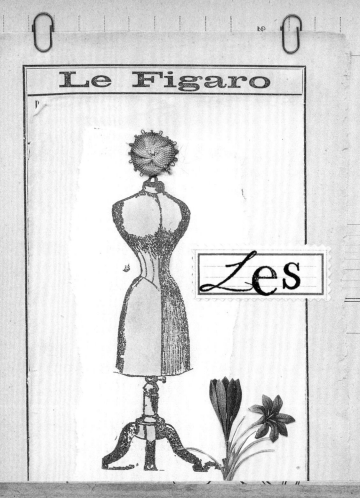

Le Figaro

Les

Accessoires

CARTE POSTALE

Ce côté est exclusivement réservé à l'adresse

Établissements Photographiques de NEURDEIN Frères. — Paris

M ACCESSORIES

Doodling *les petites choses*, the little things in life, helps illuminate the ways in which each day offers details of interest and fascination if we take the time to notice. With notebook in hand, seek out items that may not be necessities to everyday life, but help make an ordinary day more extraordinary. Objects of this nature may be tucked inside your closet, nestled on your front porch, or displayed in the window of the shop down the road. (The search is half the fun!)

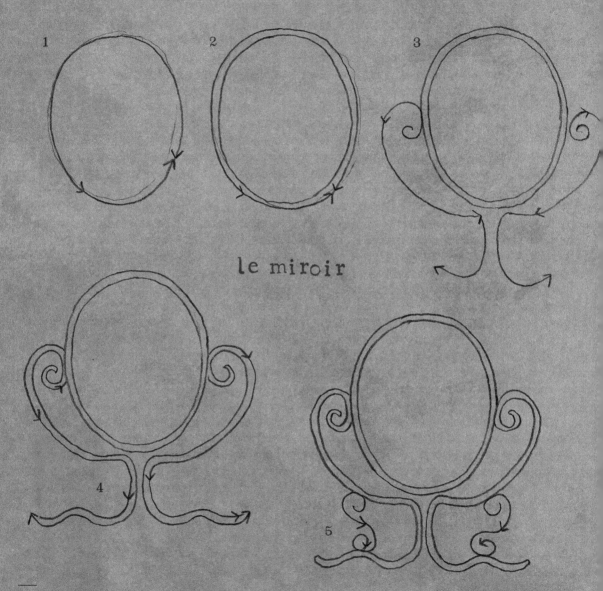

le miroir

ENTREPRISE DE SERRURERIE

L. PETIT-PIED

Rue d...

A MONTM...

Sonneries Electriques
et
A MOUVEMENT
Paratonnerres
POMPES
de
tous systèmes

Montmorillo...

Monsieur

1906
Xbre 14

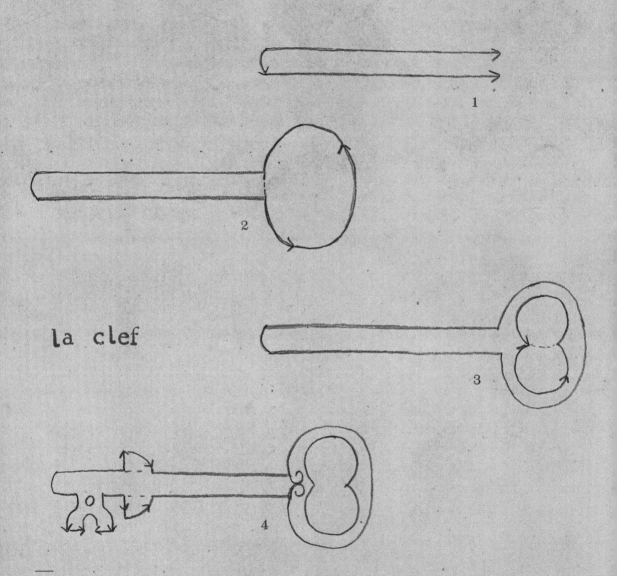

la clef

CHAUSSURES EN TOUS GENRES, CONFECTION ET MESURE

A. BORDERON

à Saint-Savin-sur-Gartempe

(VIENNE)

Tétaud

190

0,40

ous alliez au-devant du facteur. La journ
ur votre promenade était toute baignée

N° 2

AMES SAFETY
BOSTON
ENVELOPE COMPANY

cela signifie?!... murmura le Roi, de plus e

la girouette

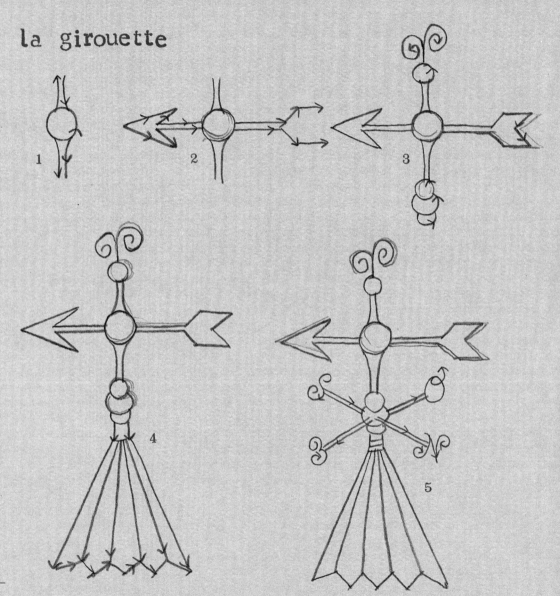

QUAI DU LOUVRE

la passementerie

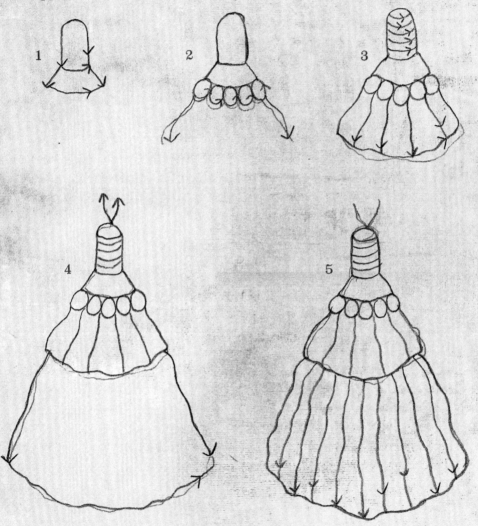

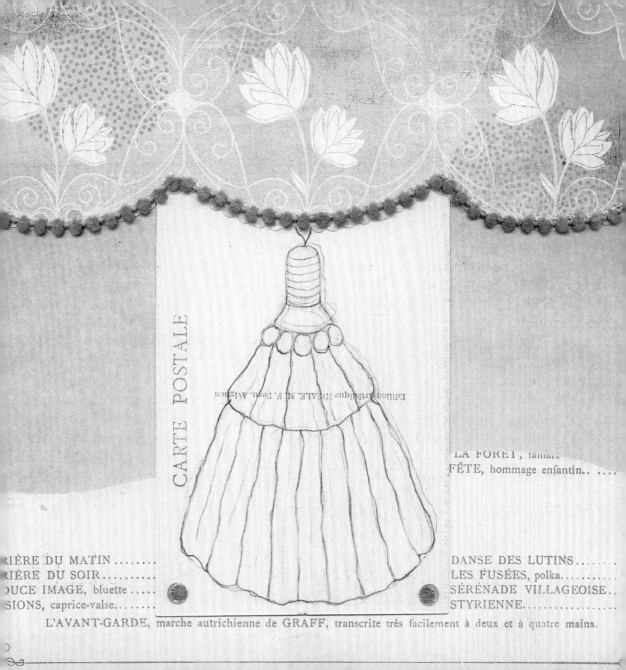

CARTE POSTALE

Edition Artistique IDEALE, M. F. Deau, Avignon

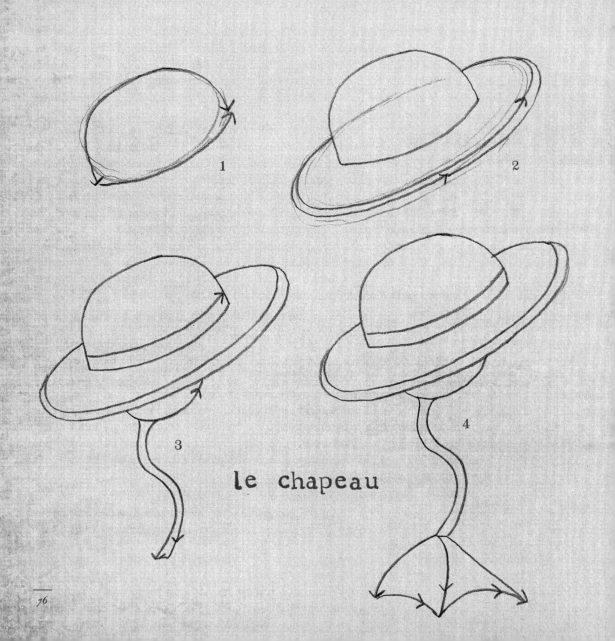

le chapeau

tableaux modernes

le parapluie

1

2

3

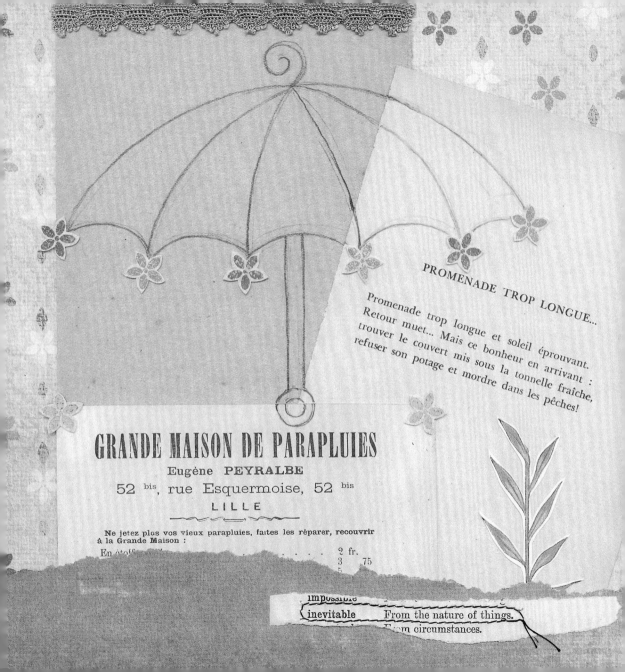

PROMENADE TROP LONGUE...

Promenade trop longue et soleil éprouvant. Retour muet... Mais ce bonheur en arrivant : trouver le couvert mis sous la tonnelle fraîche, refuser son potage et mordre dans les pêches!

GRANDE MAISON DE PARAPLUIES

Eugène PEYRALBE

52 bis, rue Esquermoise, 52 bis

LILLE

Ne jetez plus vos vieux parapluies, faites les réparer, recouvrir à la Grande Maison :

En étoff. 2 fr. 75

impossible

inevitable From the nature of things.

From circumstances.

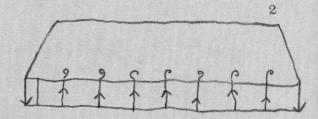

1

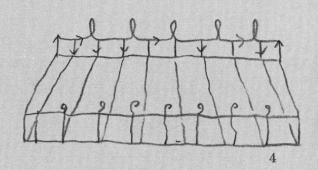

2

le plat du savon

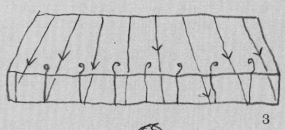

3

4

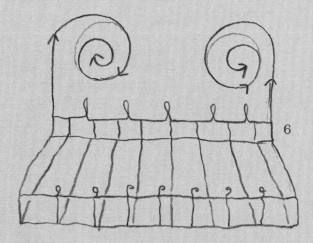

5

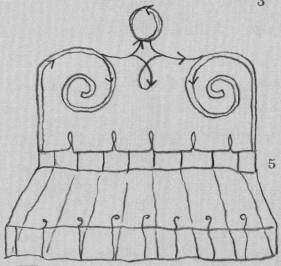

6

le pichet émaillé

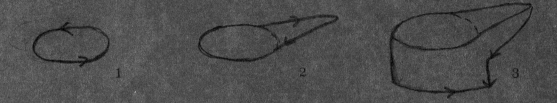

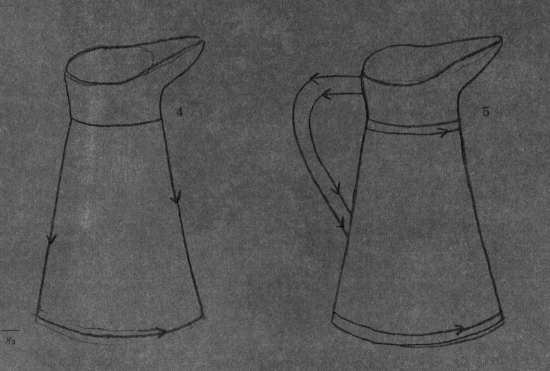

Modes

Poities, le 7 Juillet — 1884.

Madame Mérieux

50, Rue St François

3 ♣

...toutes les
...les moines ; tout un chacun
...de coraule est finie....

...uit bon demeurer et, lorsqu'on
...ner. Il y a fait bon régner, quand

JEAN DE LA FONTAI...

CONTES

ET

NOUVELLES EN VERS

ILLUSTRATIONS DE FRAGONARD

b, c, d,
j, k, l, m, n,
r, s, t, v, x, z.

ALPHABET

a.b.c.d.e.f.g.h.i.j.k.l.m.n.
o.p.q.r.s.t.u.v.x.y.z.

s. — (1) Faire lire, copier, reconnaître les lettres de façon à ce que les enfants n'a...
tation, soit pour la distinction des lettres ou pour leur reproduction. Cela est essenti...
...sser aux exercices ou leçons du deuxième livret. — Il conviendra aussi de revenir sur la...
itulative qui suit (page 4 du présent livret). Les élèves ne sauraient être trop familiarisé...

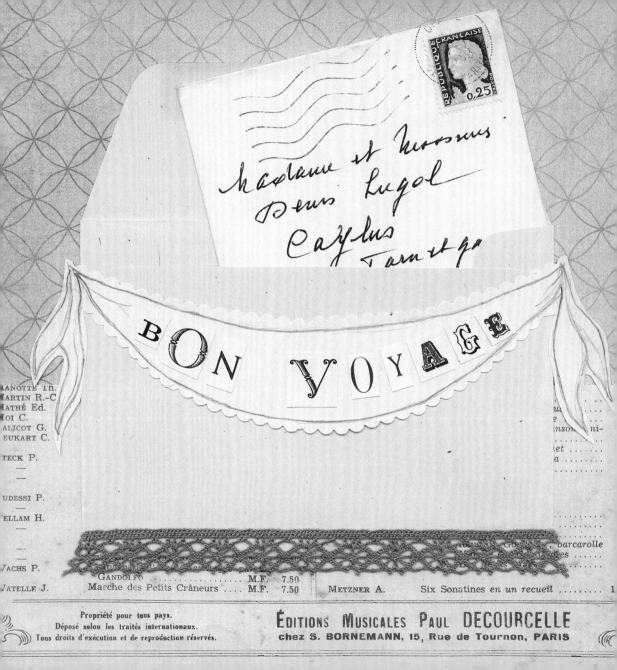

BON VOYAGE

RANOTTE Th.
MARTIN R.-C
MATHÉ Ed.
MOI C.
ALICOT G.
EUKART C.

TECK P.
—

UDESSI P.

ELLAM H.

—
—

JACHS P.

JATELLE J.

GANDOLFO M.F. 7.50
Marche des Petits Crâneurs M.F. 7.50

METZNER A. Six Sonatines en un recueil 1

ÉDITIONS MUSICALES PAUL DECOURCELLE
chez S. BORNEMANN, 15, Rue de Tournon, PARIS

GOOD JOURNEY

Trains, planes, and *bicyclettes*. They carry us
to faraway lands or nearby settings, ruffling up
our routines to let some sunshine in. Use these
out-of-the-ordinary days when your horizons have
been broadened as fodder for new doodle discover-
ies. Send postcards home with images seen from
your hotel balcony or across the boardwalk on
a warm, breezy afternoon. These hand-drawn sou-
venirs will be lasting keepsakes in a way that
other forms of messaging will never be.

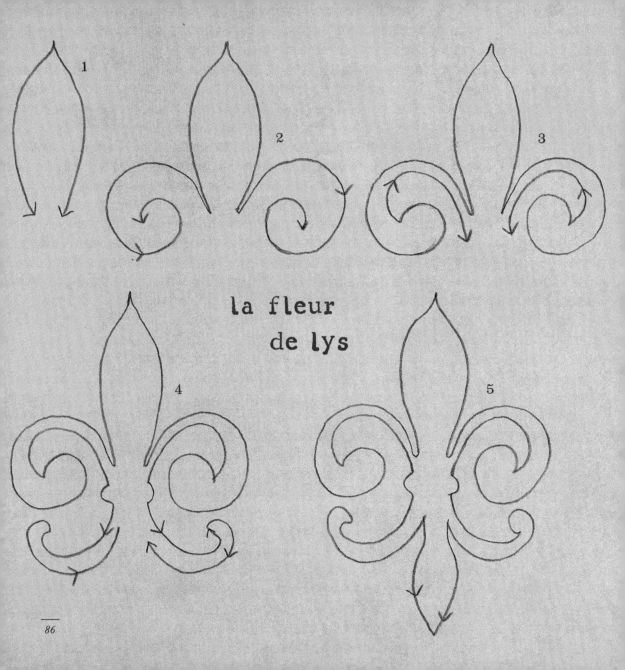

la fleur
de lys

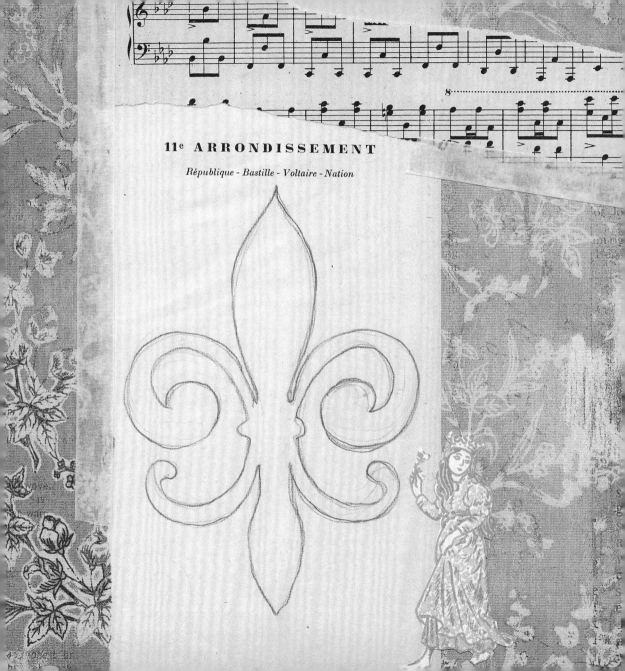

11ᵉ ARRONDISSEMENT

République - Bastille - Voltaire - Nation

1

l'enveloppe

2

IVᵉ Année. 10 CENTIMES LE NUMÉRO ❋ Dimanche 29 Septembre 1912 P.

Petit Echo de la Mode

Téléphone 818-5

Baronne de CLESSY, rédactrice en chef.

M. ORSONI, Directeur

BUREAUX : 7, rue Lemaignan, PARIS

Saint Michel
Les jours décroissent de 1 h. 47ᵉ

famille, mes meilleurs souvenirs
Aline Veyssières
épouse Garcia.
P.S. Je suis remarié depuis
20 - Octobre 1921

Mme Garcia
25, rue Hertz
Vincennes

le cadeau

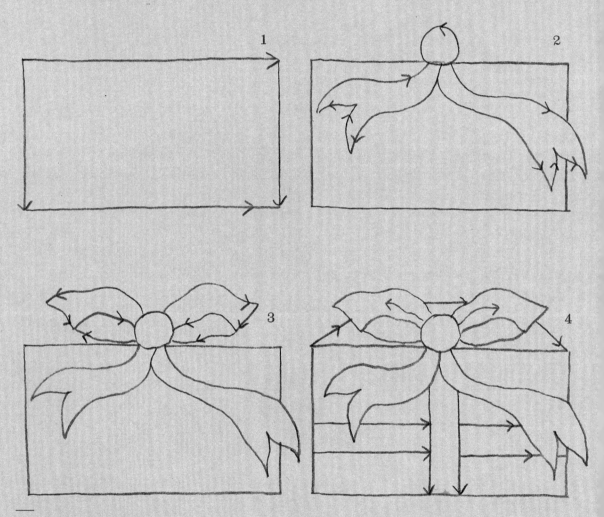

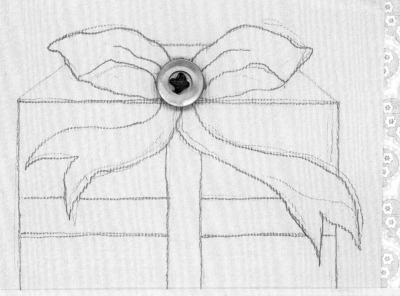

PARFUMERIE DU NORD

132 & 134, Rue Lafayette, PARIS

MÉDAILLES

OR, ARGENT ET BRONZE

SAVONS SURFINS

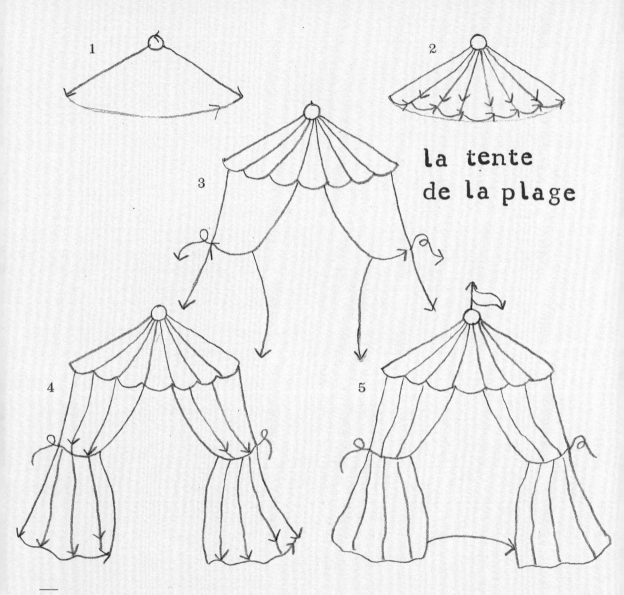

la tente
de la plage

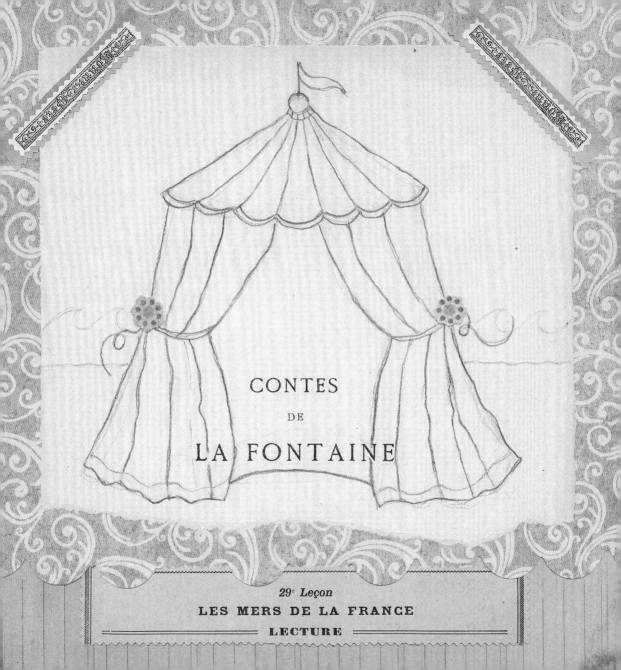

CONTES

DE

LA FONTAINE

29ᵉ Leçon

LES MERS DE LA FRANCE

LECTURE

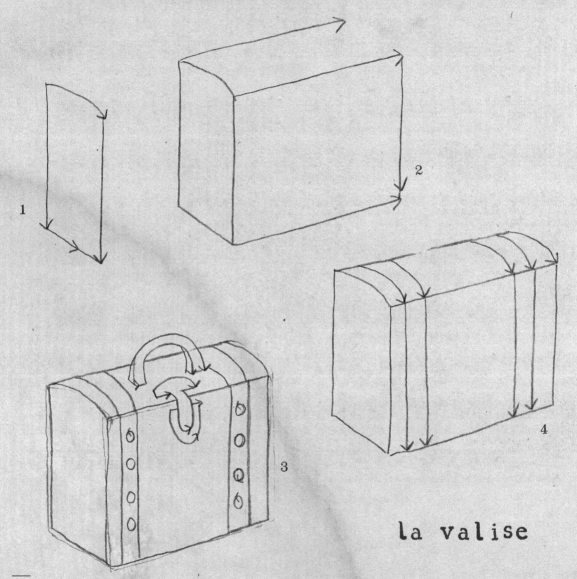

1

2

3

4

la valise

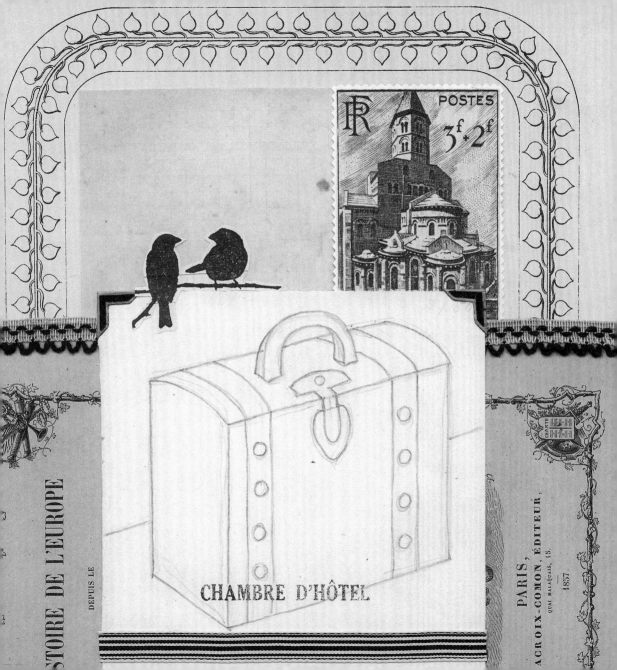

POSTES

3ᶠ*2ᶠ

CHAMBRE D'HÔTEL

STOIRE DE L'EUROPE

DEPUIS LE

PARIS,
ACROIX-COMON, ÉDITEUR,
QUAI MALAQUAIS, 15.
1857

le cheval du carrousel

1

2

3

4

11. *Mardi*. S. Gomer. S. Quirin. 285-81

12. *Mercredi*. S. Séraphin. S. Wilfrid 286.

POPOT - LEMOULT

Grands Magasins de Nouveautés

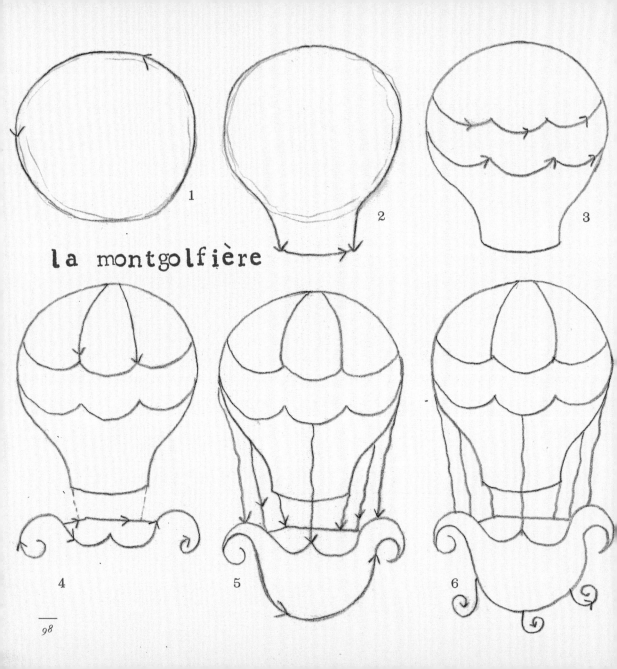

la montgolfière

1

2

3

4

5

6

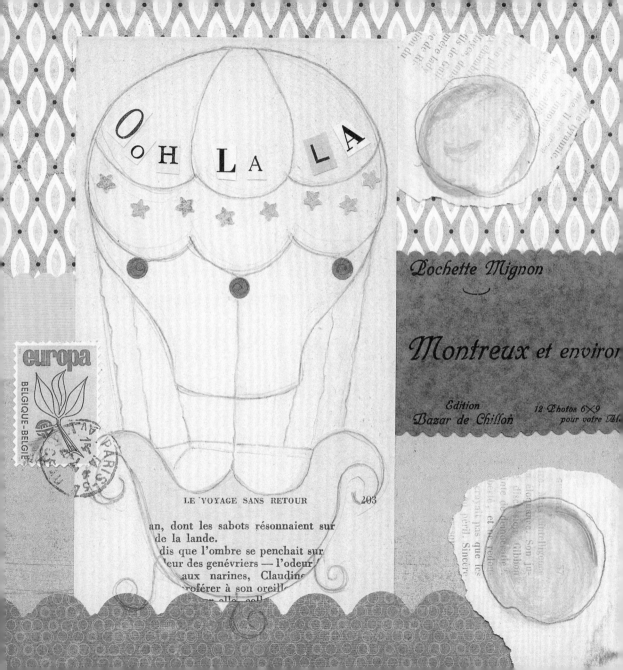

la tour eiffel

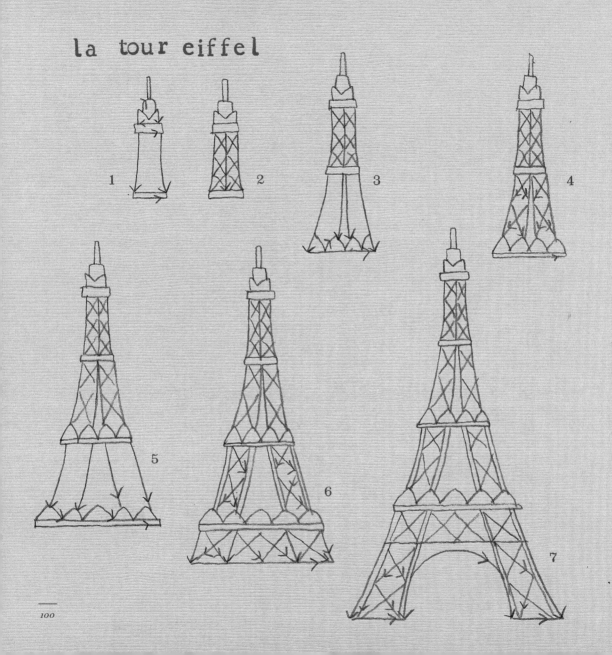

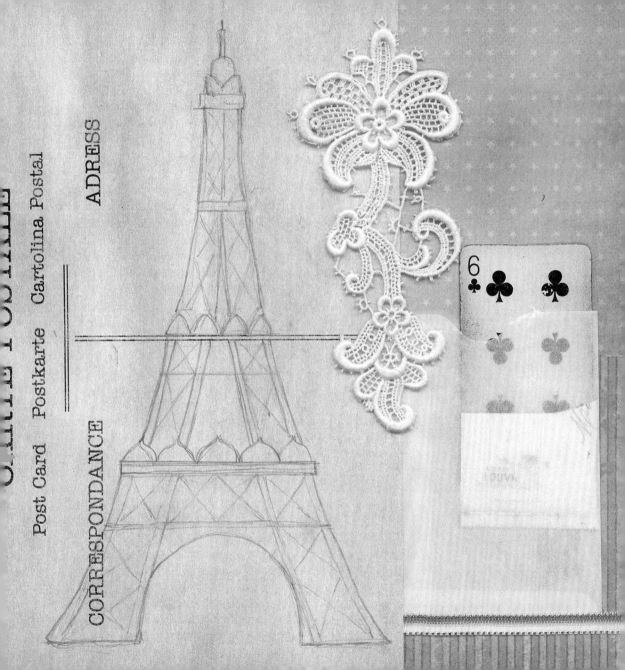

CARTE POSTALE

ADRESS

Post Card Postkarte Cartolina Postal

CORRESPONDANCE

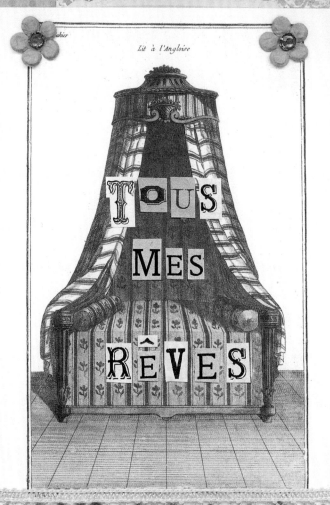

Lit à l'Angloise

TOUS MES RÊVES

ALL MY DREAMS

Ultimately, what better place to doodle than in our dreams?
Tracing stardust with our imaginations, we create out-
lines of fantasy and longing that perceive no boundaries
or limitations. All is possible. Where will your musings
take you today, tonight, tomorrow? What vast or simple nug-
get pulls at your heartstrings? Follow these threads of
desire, the very stuff of which dreams are made, and watch
where you are taken. It just may be over the moon.

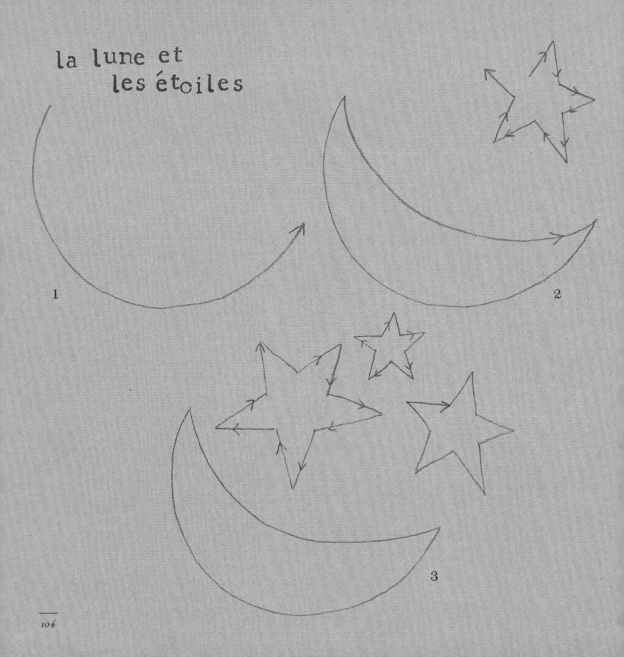

la lune et
les étoiles

1

2

3

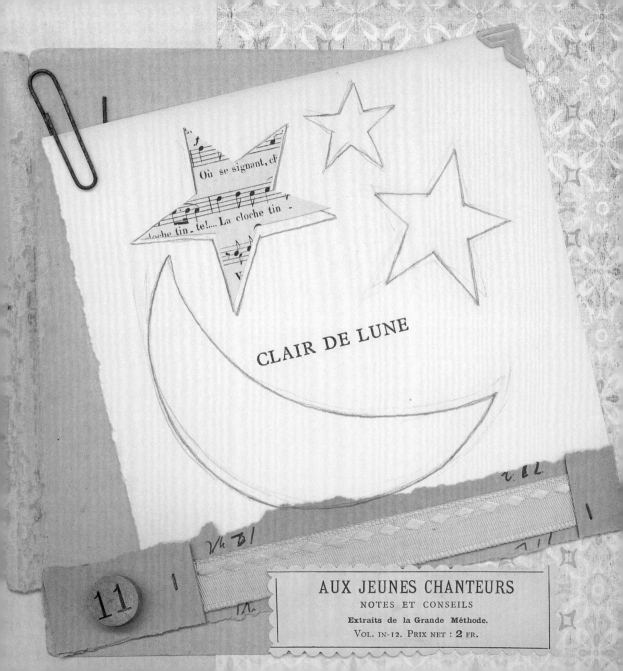

CLAIR DE LUNE

AUX JEUNES CHANTEURS
NOTES ET CONSEILS
Extraits de la Grande Méthode.
VOL. IN-12. PRIX NET : **2** FR.

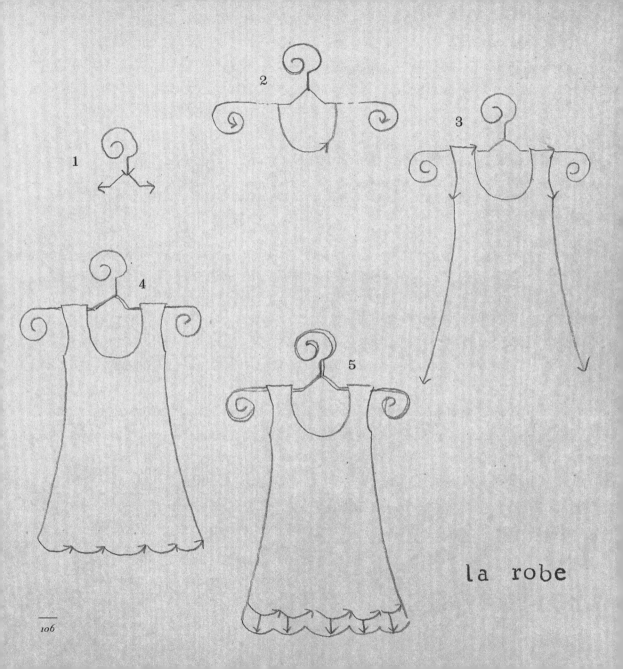

1

2

3

4

5

la robe

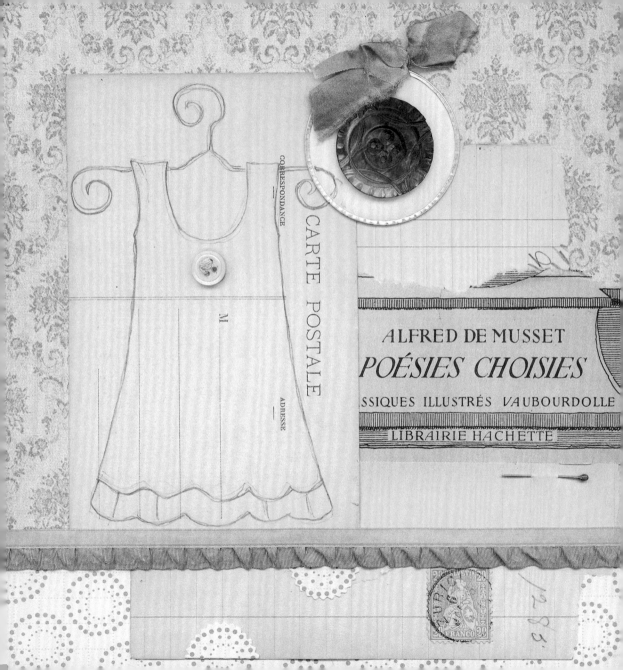

CARTE POSTALE

CORRESPONDANCE

ADRESSE

ALFRED DE MUSSET
POÉSIES CHOISIES
SSIQUES ILLUSTRÉS VAUBOURDOLLE
LIBRAIRIE HACHETTE

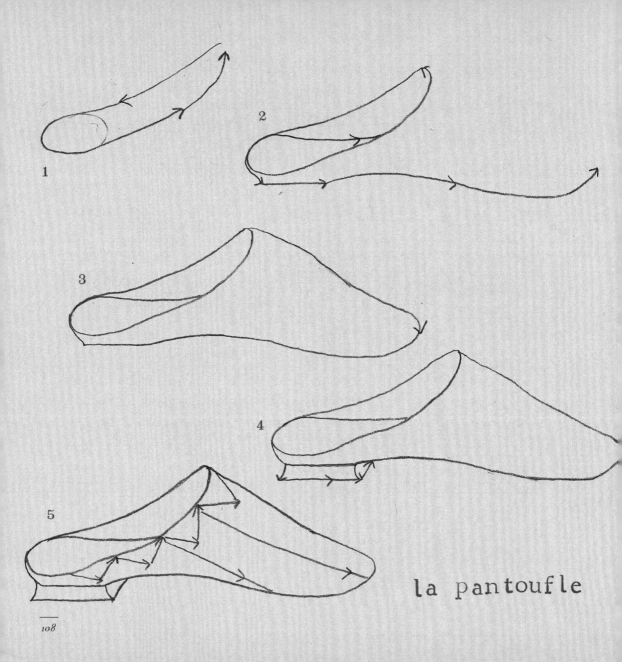

1

2

3

4

5

la pantoufle

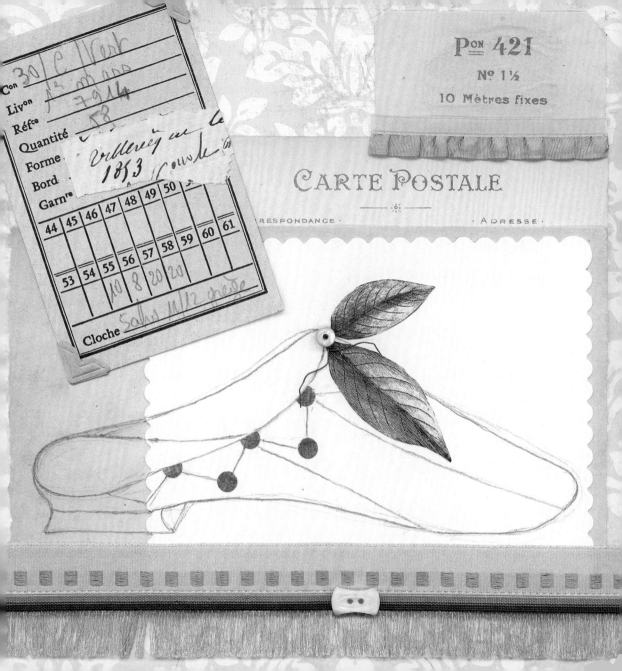

CARTE POSTALE

·❋·

CORRESPONDANCE · · ADRESSE ·

C^{on}	30	C	Vert
Liv^{on}			
Réf^{ce}	7914		
Quantité	58		
Forme			
Bord			
Garn^{re}			

Ordonné en le
1853

44	45	46	47	48	49	50		
53	54	55	56	57	58	59	60	61
			10	8	20	20		

Cloche

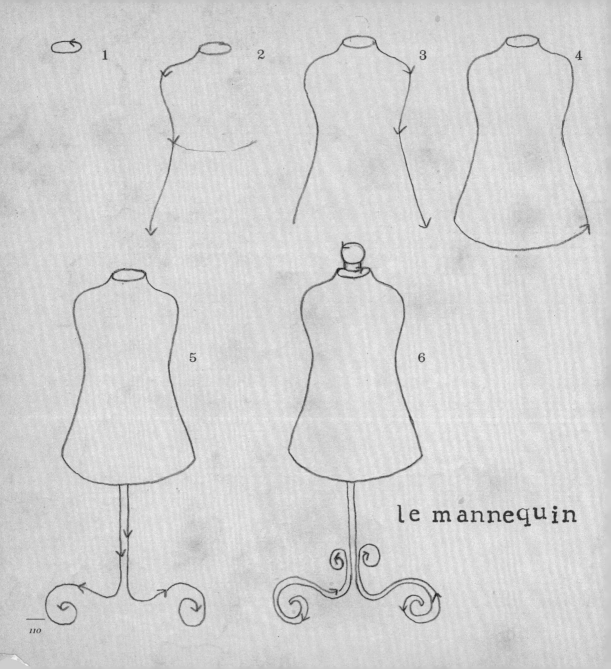

1 2 3 4

5 6

le mannequin

le gâteau

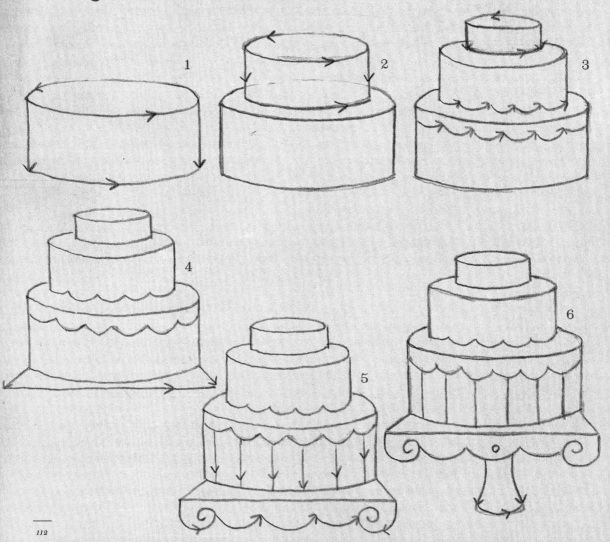

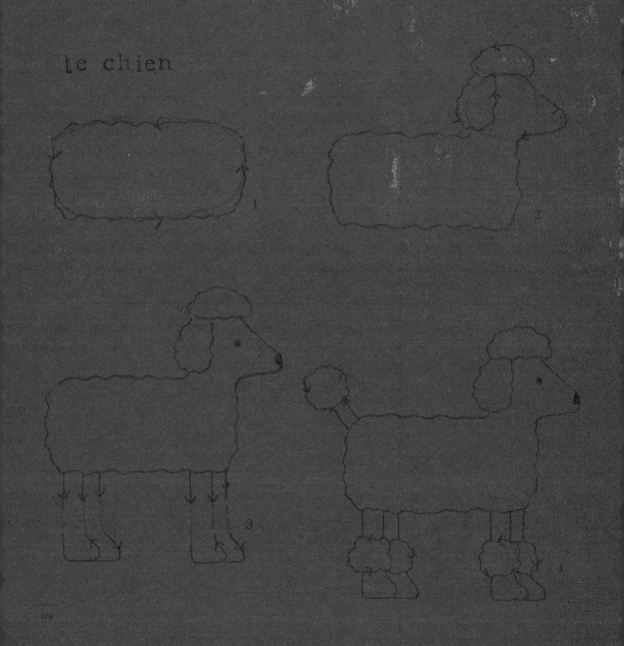

le chien

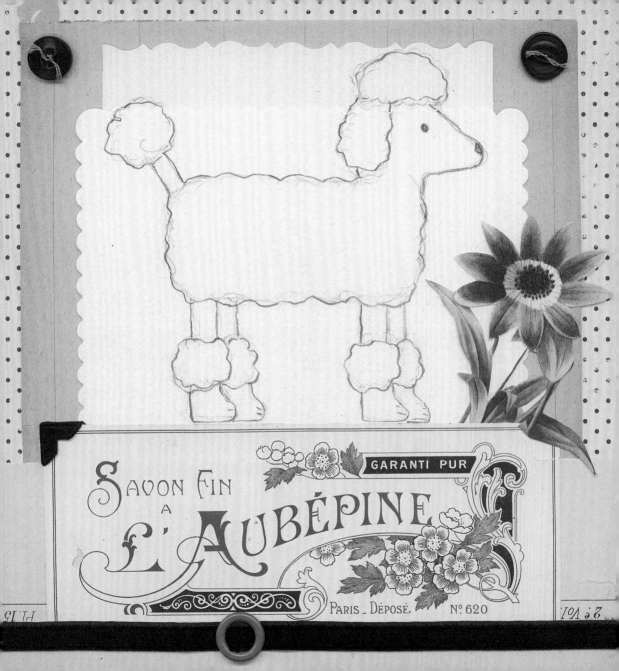

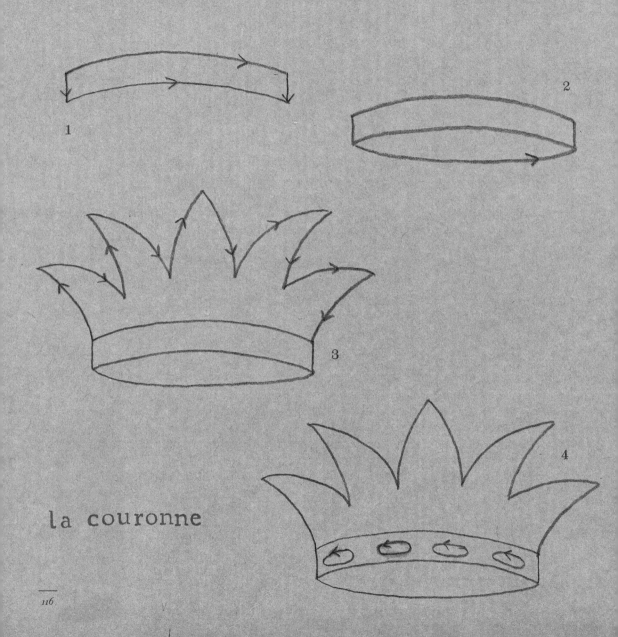

la couronne

MÉLODIES DE J. FAURE

PUBLIÉES

AU *MÉNESTREL*, 2 *bis*, RUE VIVIENNE

QUATRIÈME VOLUME

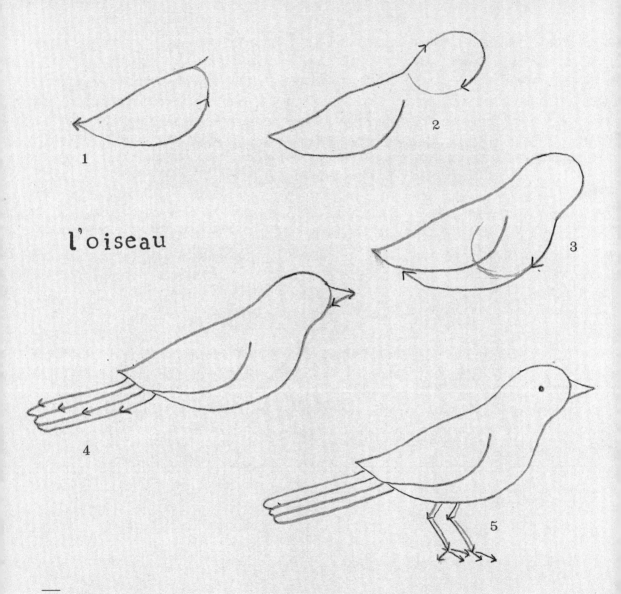

l'oiseau

1

2

3

4

5

DICTIONNAIRE

UNIVERSEL

D'HISTOIRE NATURELLE

PARIS

AU BUREAU PRINCIPAL DE L'ÉDITEUR

2.

PER VIA AEREA

Mod. 24-R bis

Carte Postale

Adresse

Correspondance

FIN

ET MAINTENANT...

AND NOW...

(pages for your doodling enjoyment)

45

ALFRED DE MUSSET

ÉVÉNEMENTS HISTORIQUES	VIE ET ŒUVRES	ÉVÉNEMENTS LITTÉRAIRES

IMPRIMÉ EN FRANCE IMP. L'OFF-SET-LEVALLOIS

PARIS. — IMPRIMERIE DE E. MARTINET, RUE MIGNON, 2.

...und doch fühle ich

...er Schmerz, beschwert dein Herz,

24